James Tissot (1836–1902). L'Ambitieuse (The Political Woman), 1883–5; oil on canvas. From Six Tissot Cards, © 2001 Dover Publications, Inc.

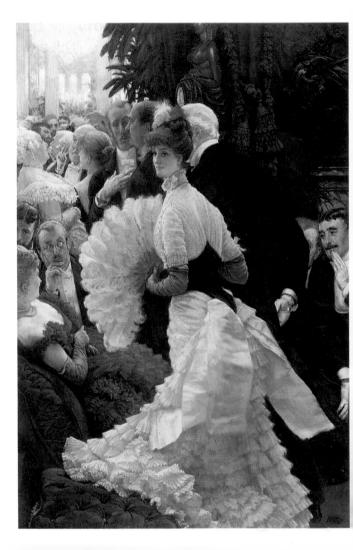

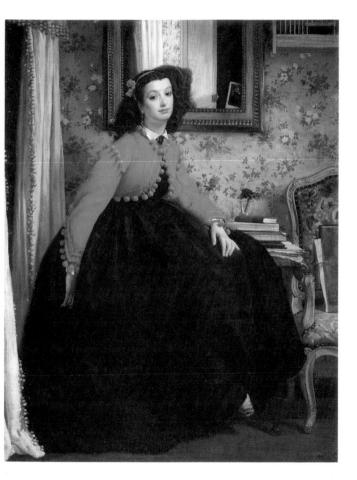

James Tissot (1836–1902). Mlle. L. L. . . (Jeune Femme en veste rouge; Young Woman in Red Jacket), 1864; oil on canvas. From Six Tissot Cards, © 2001 Dover Publications, Inc.

James Tissot (1836–1902). *October*, 1877; oil on canvas. From *Six Tissot Cards*, © 2001 Dover Publications, Inc.

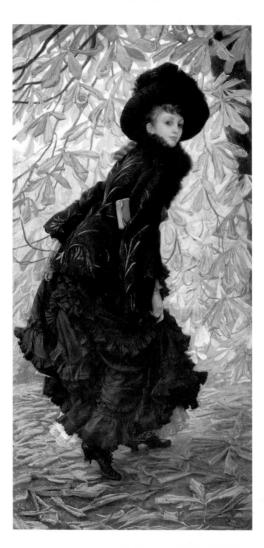

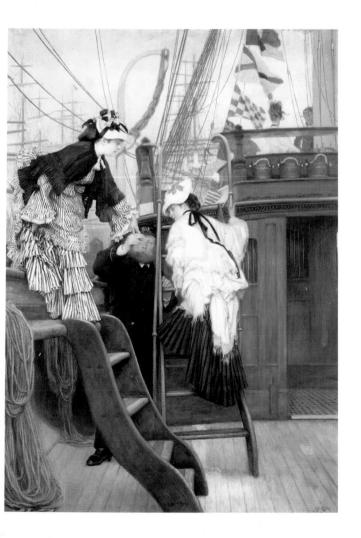

James Tissot (1836–1902). *Boarding the Yacht*, 1873; oil on canvas. From *Six Tissot Cards*, © 2001 Dover Publications, Inc.

James Tissot (1836–1902). Portsmouth Dockyard, ca. 1877; oil on canvas. From Six Tissot Cards, © 2001 Dover Publications, Inc.

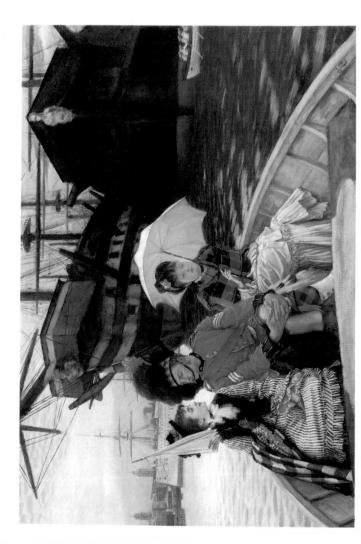

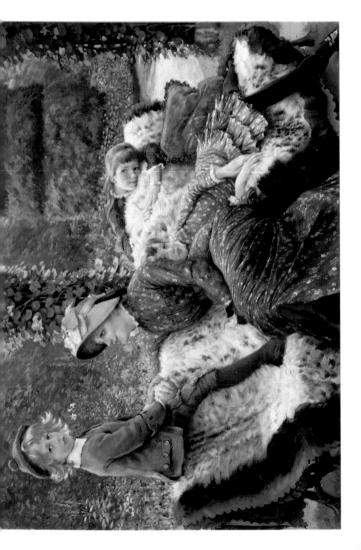

James Tissot (1836–1902). *Le Banc de jardin (The Garden Bench)*, ca. 1882; oil on canvas. From *Six Tissot Cards*, © 2001 Dover Publications, Inc.